sketches alive

Peter Slater

Copyright © 2019 by Peter Slater All rights reserved. This book or anyportion thereof may not be reproduced or used in anymanner whatsoever without the express written permission ofthe publisher except for the use of brief quotations in a book review. Printed in the United States of America

HENRI MATISSE. "CREATIVITY TAKES COURAGE"

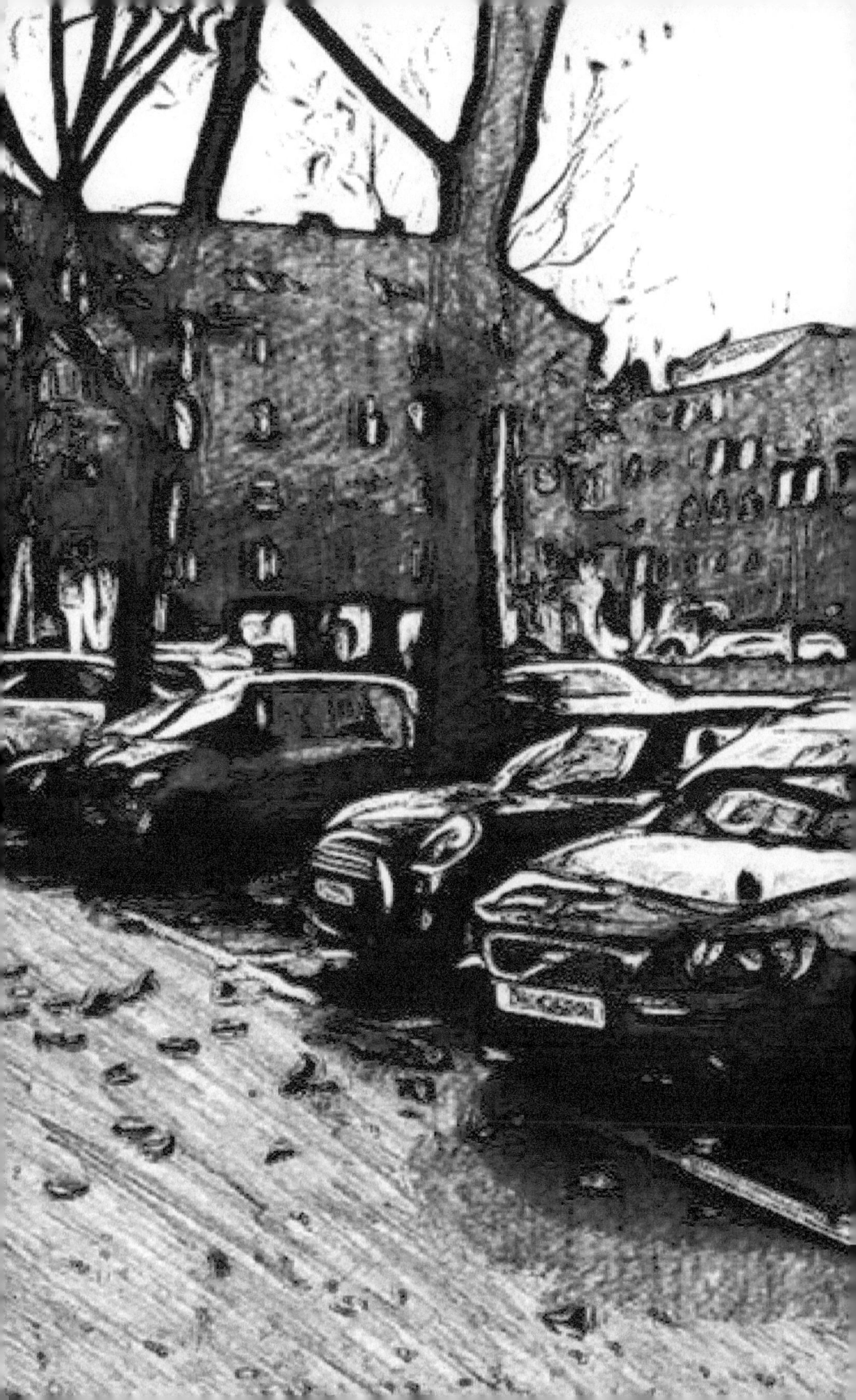

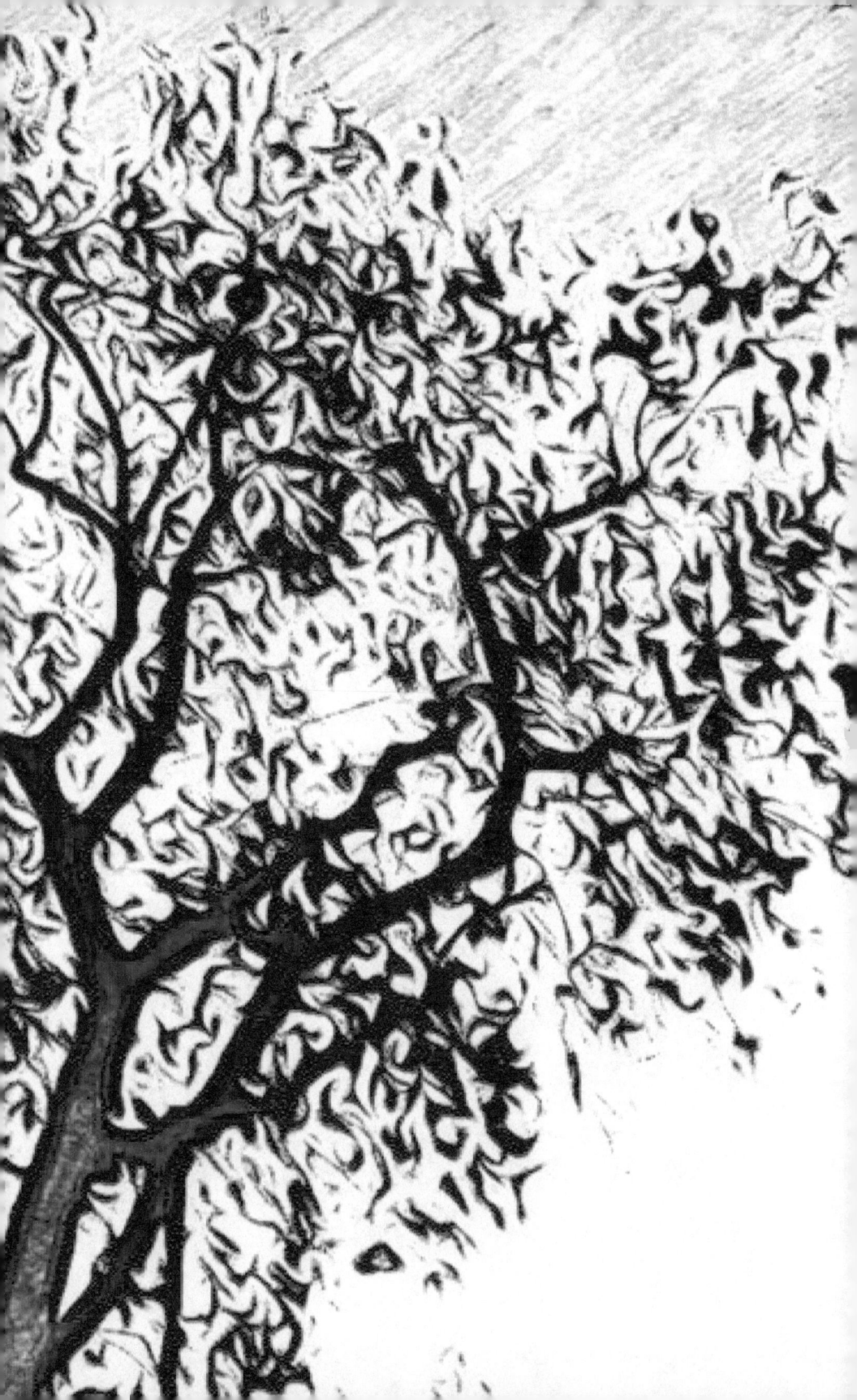

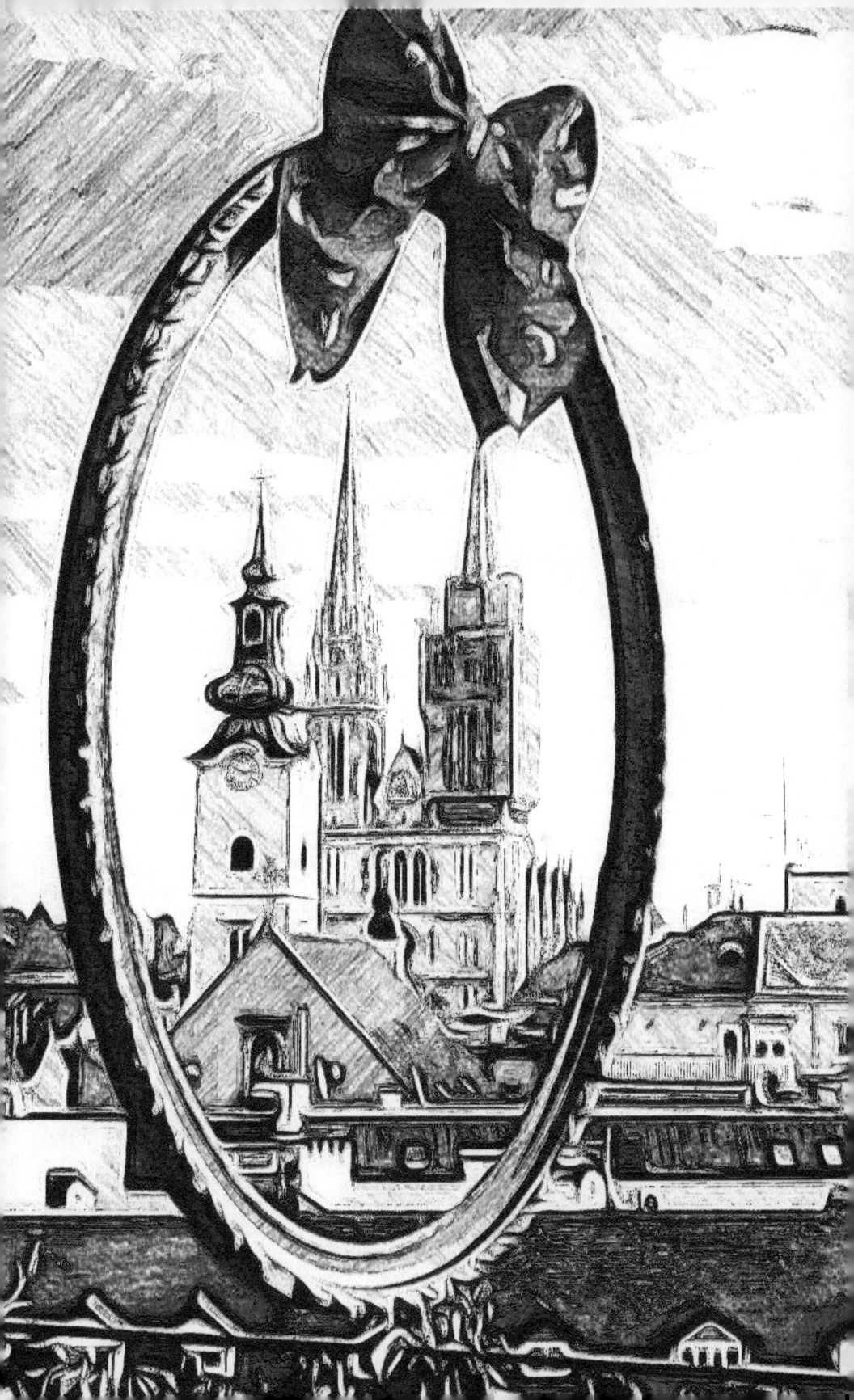

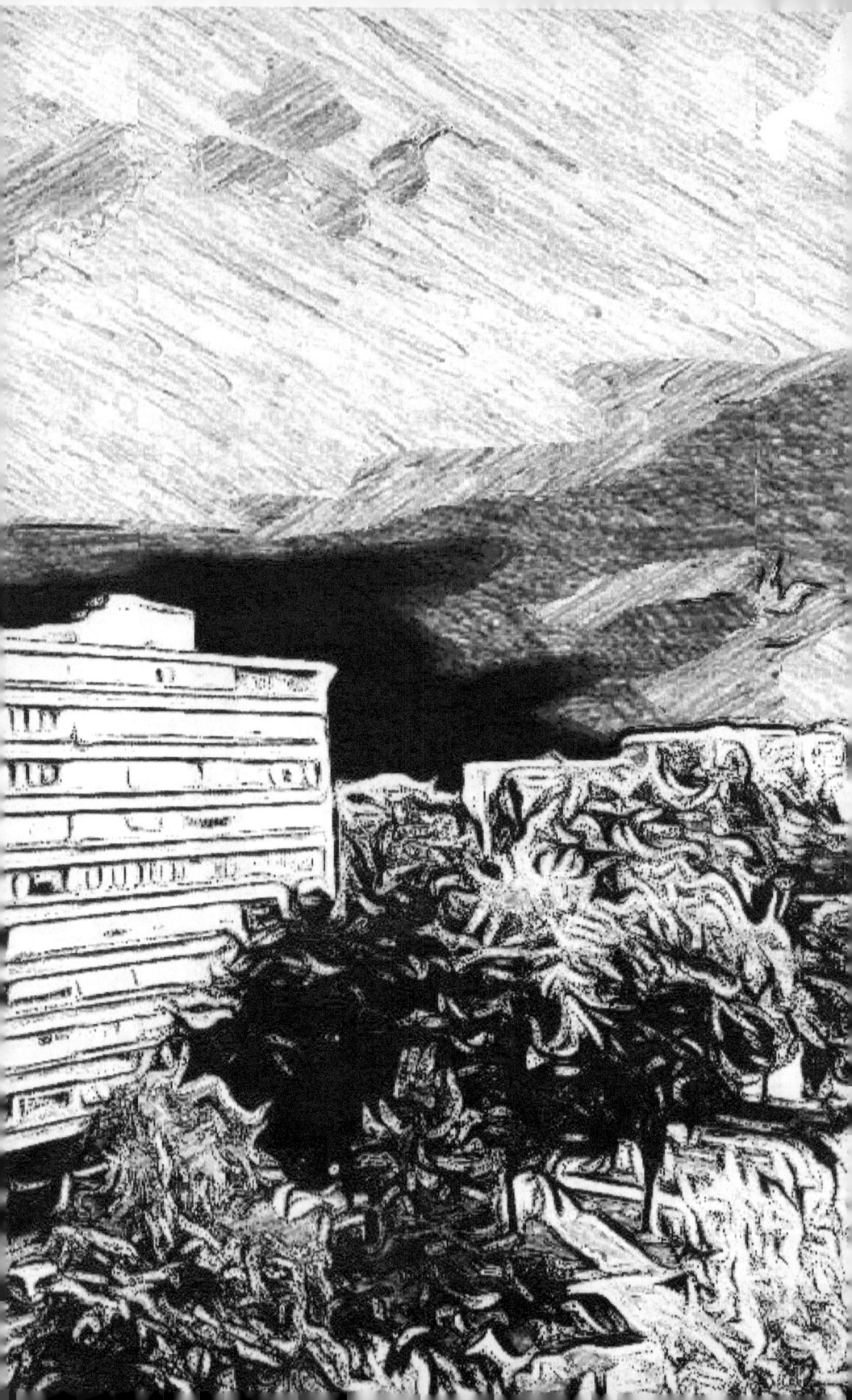

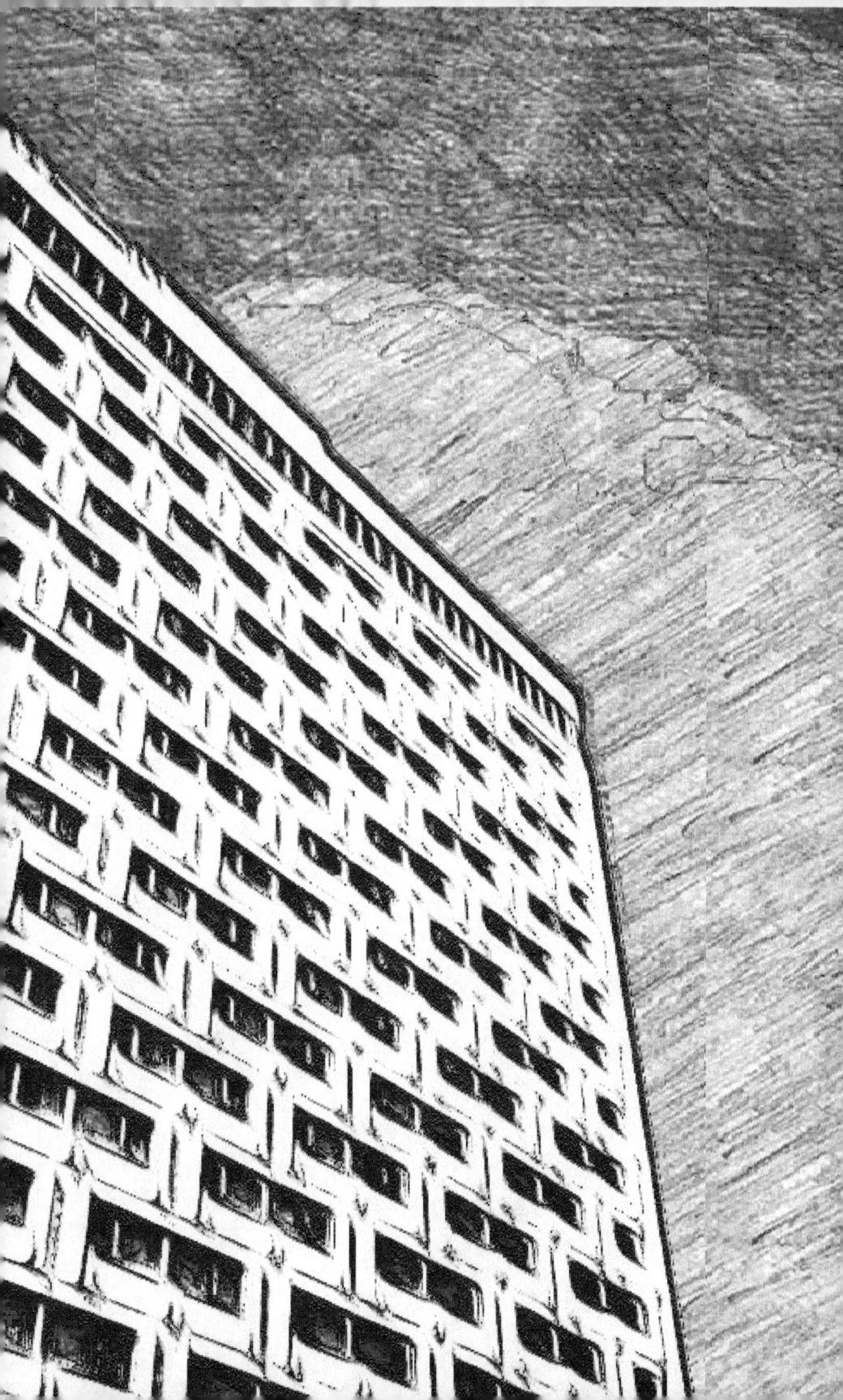

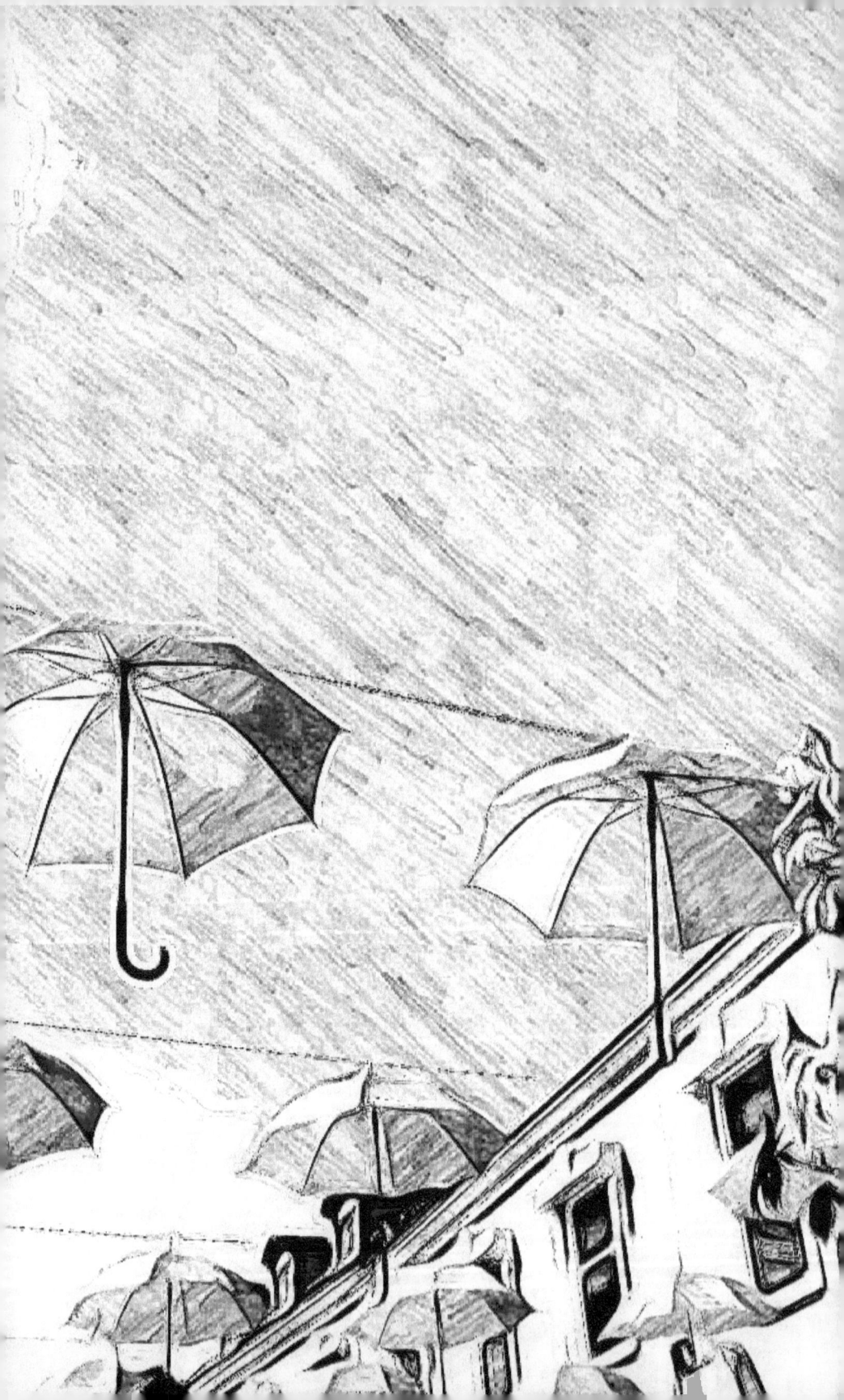

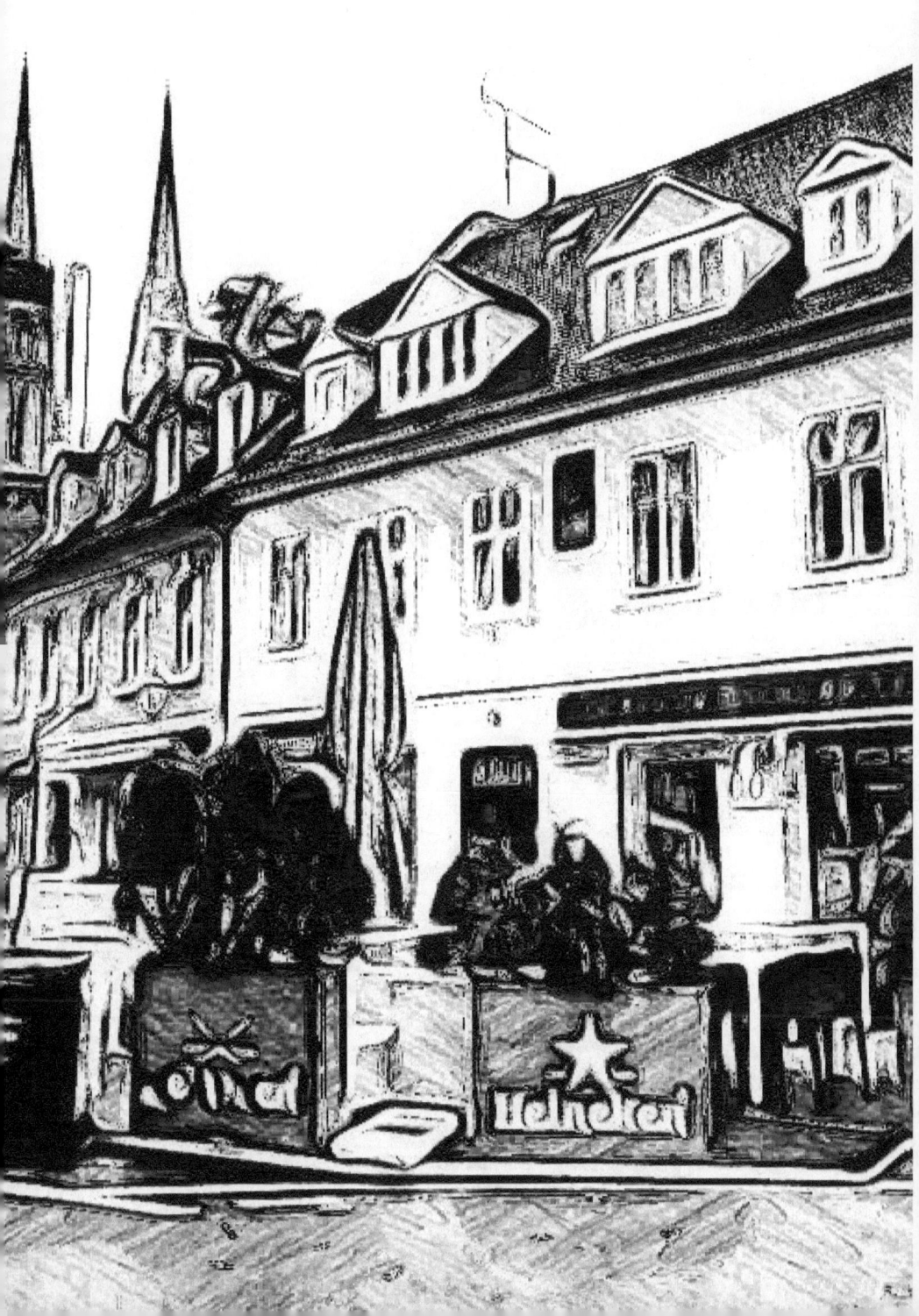

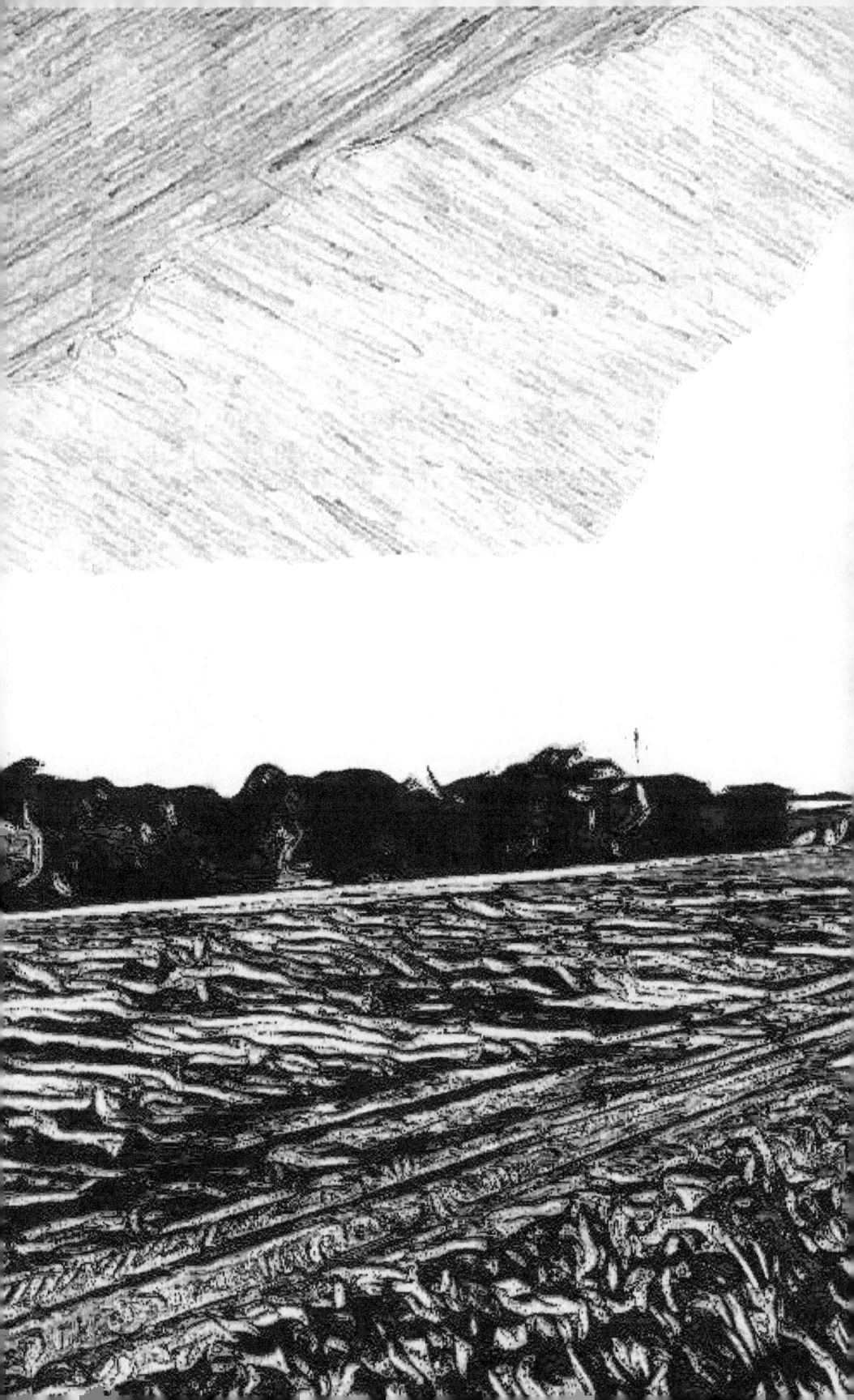

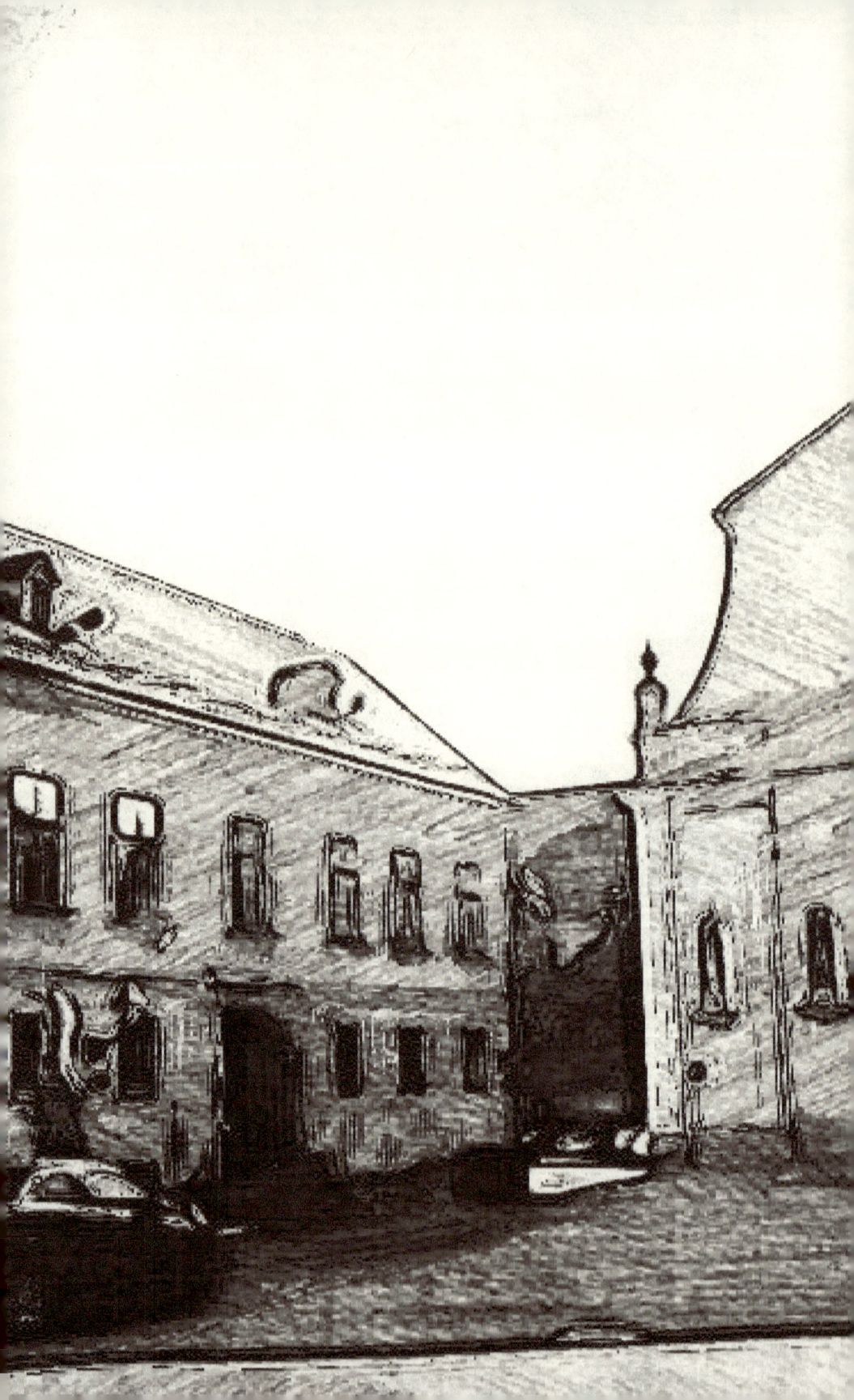

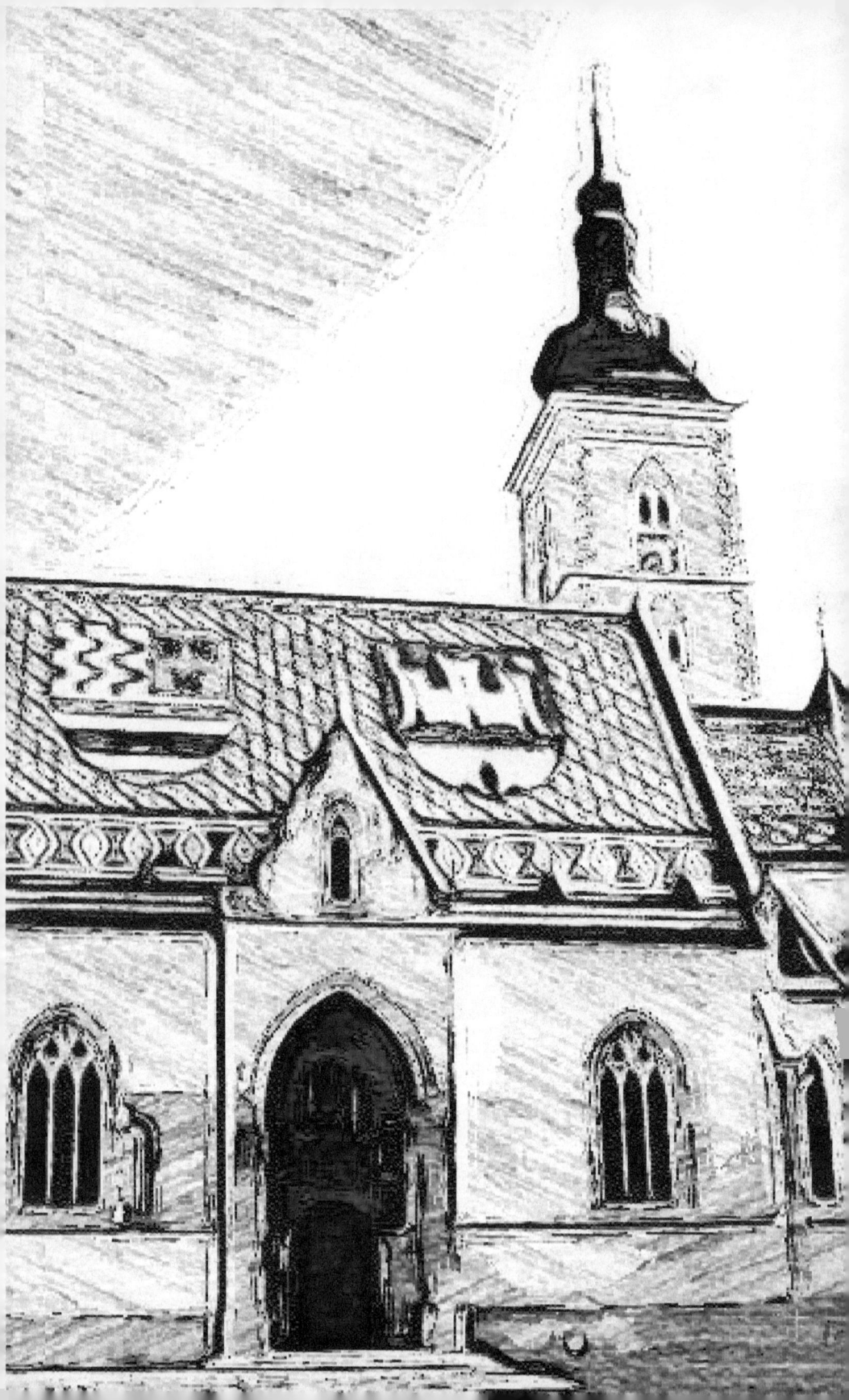

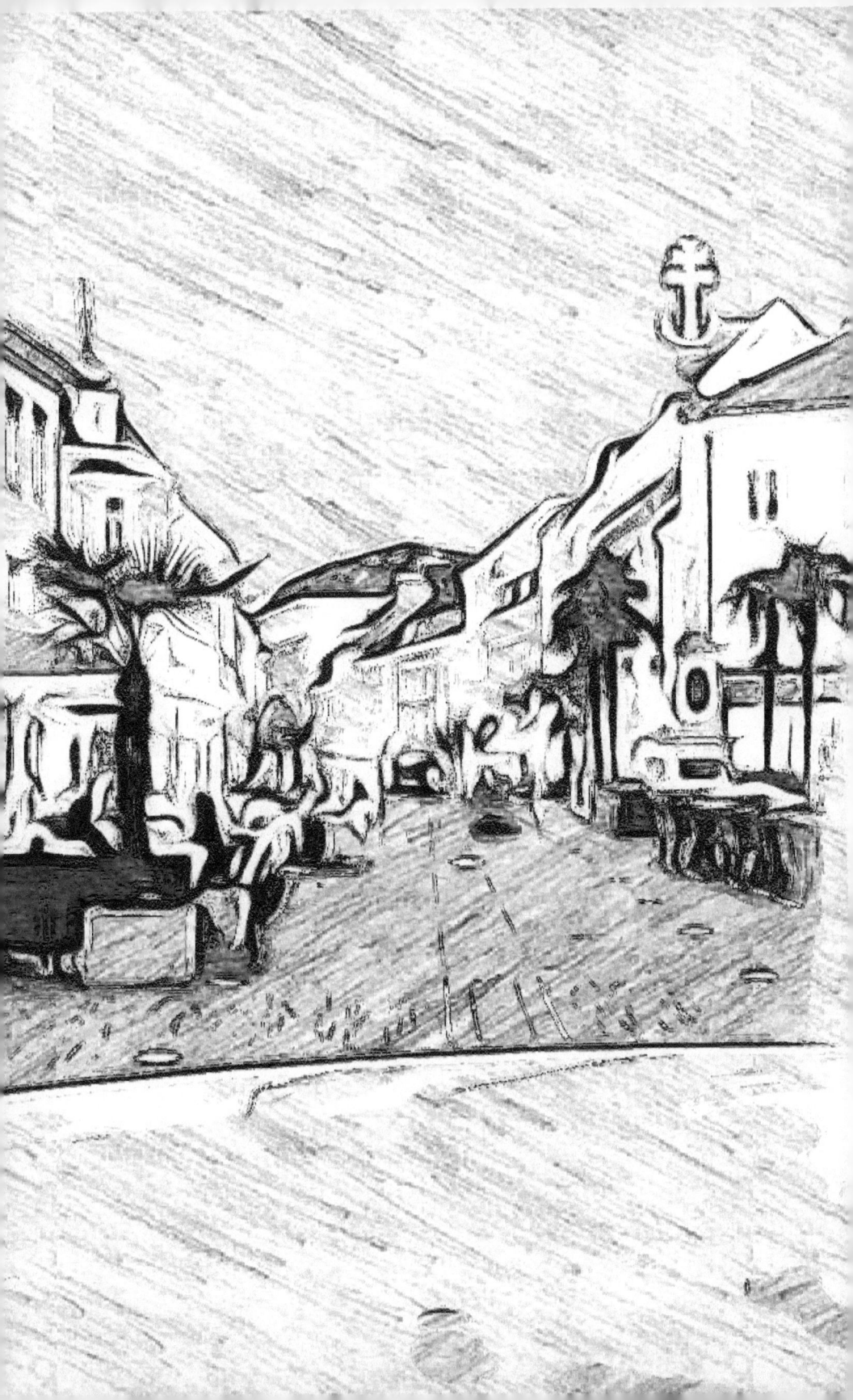

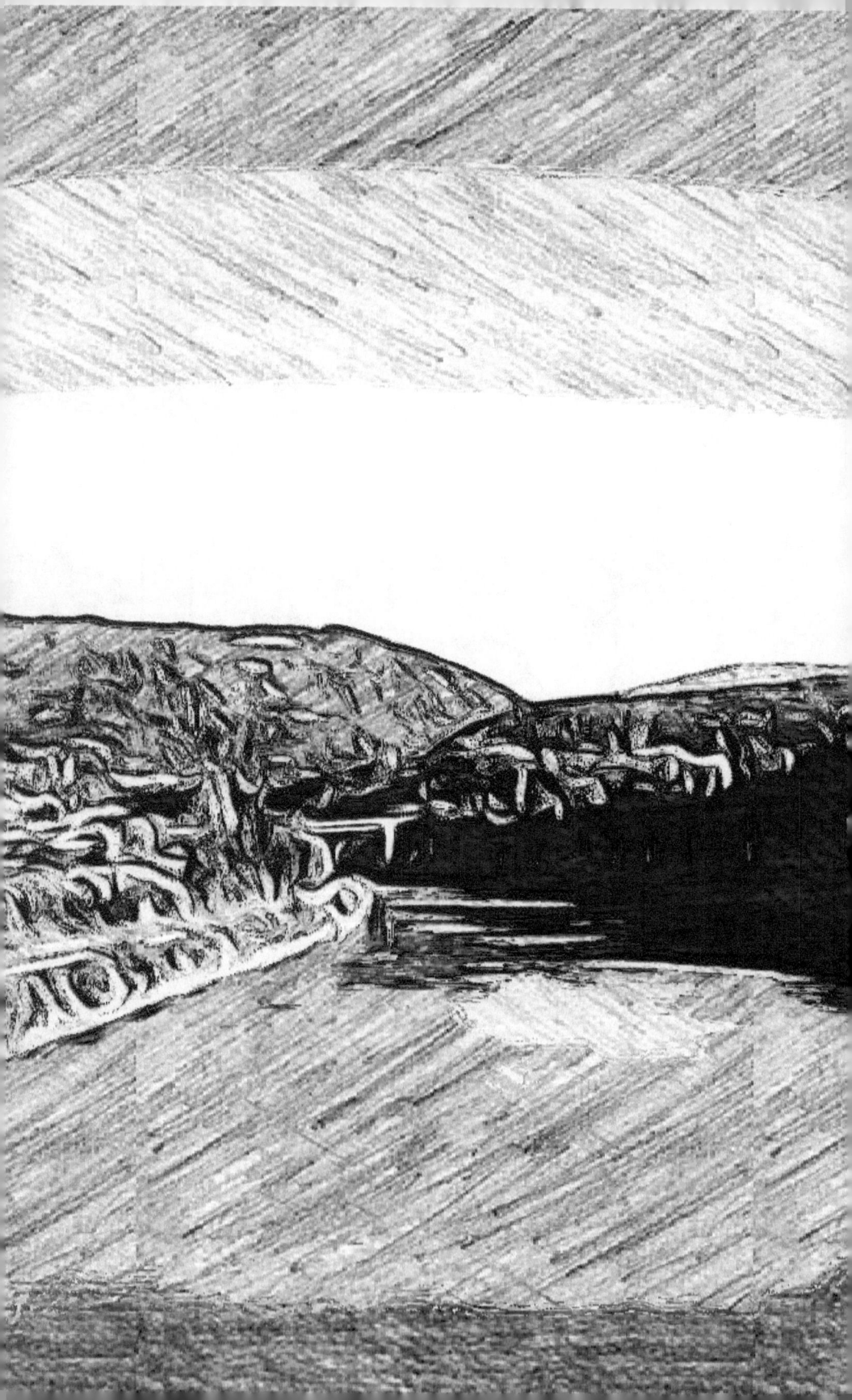

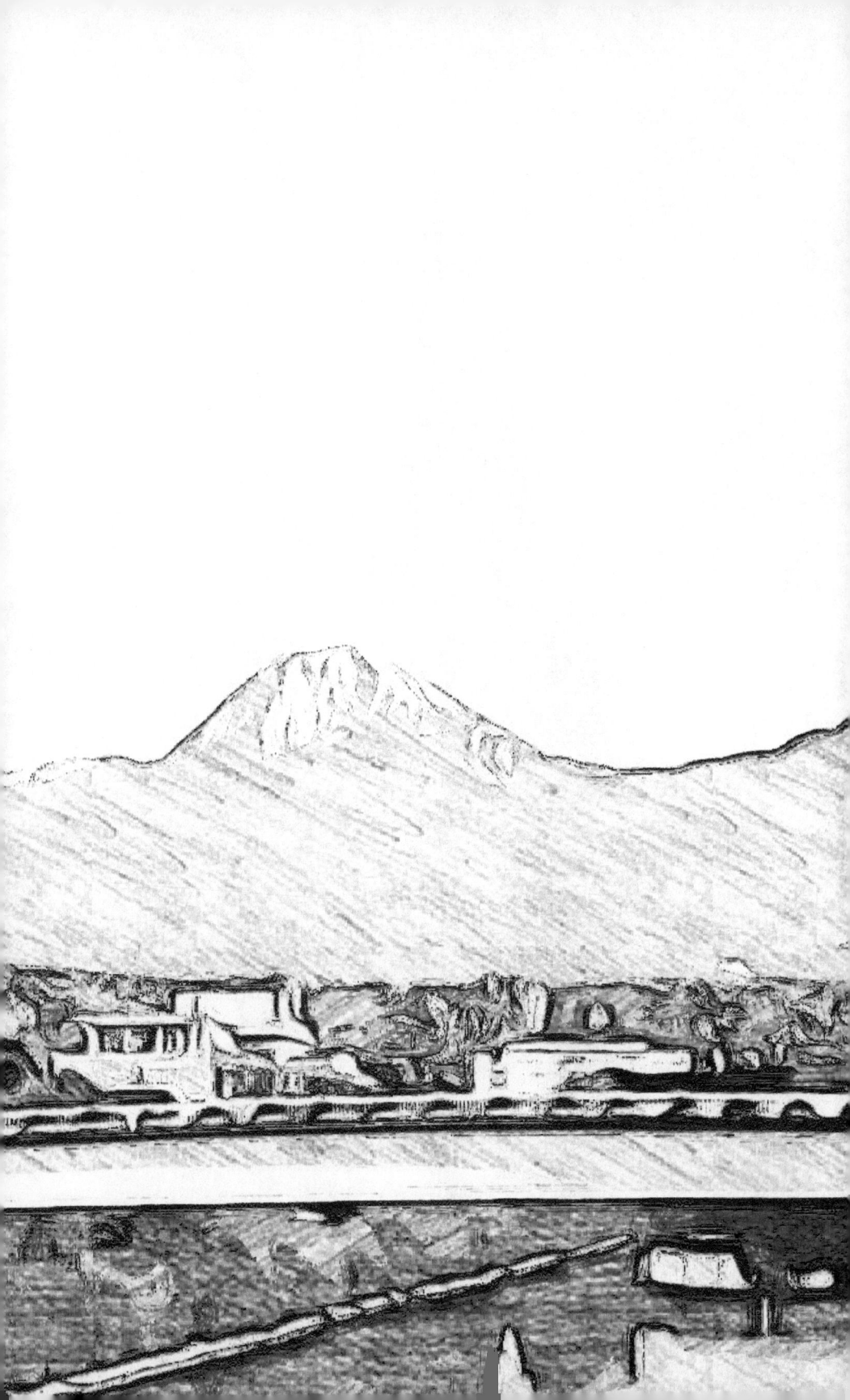

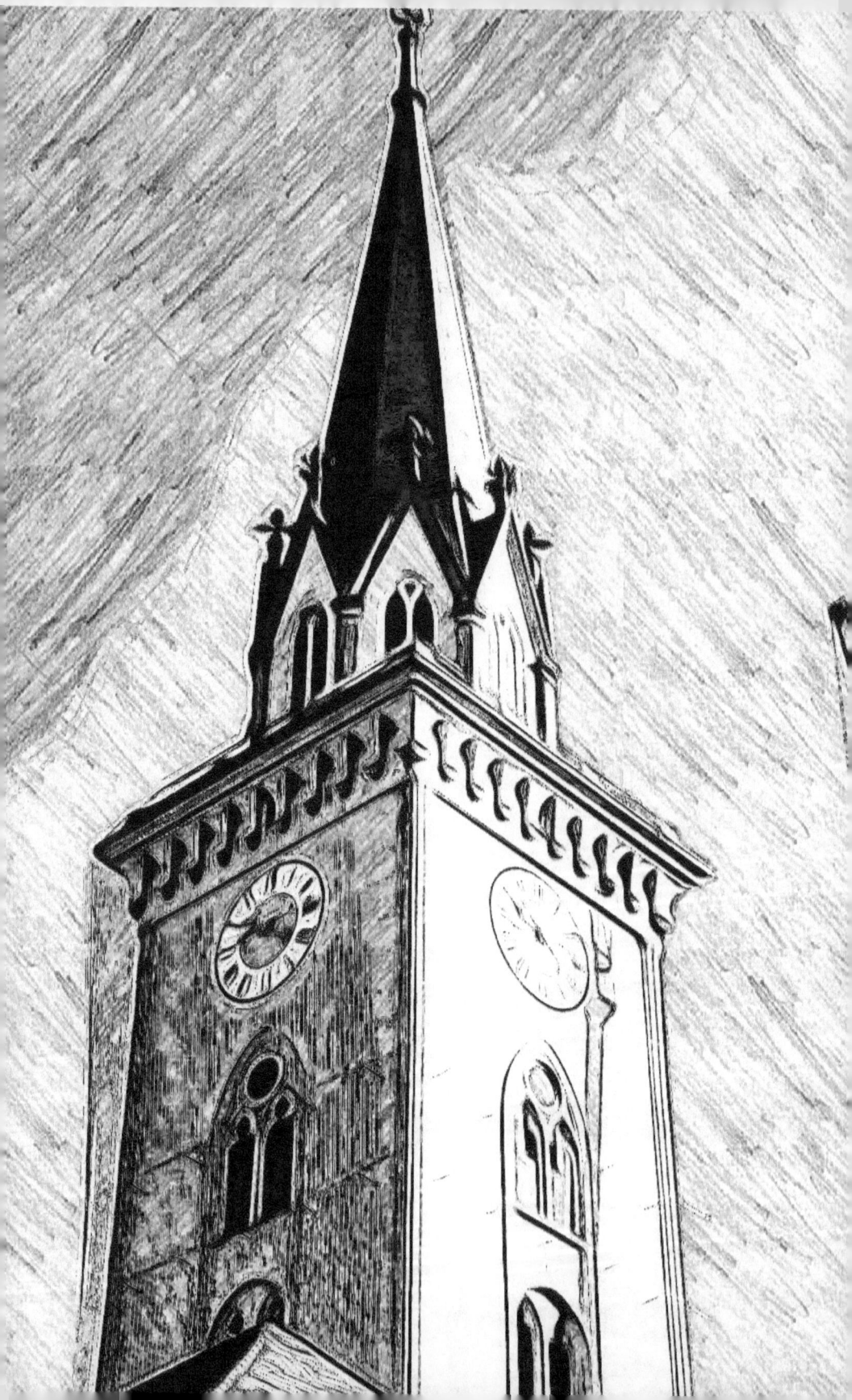

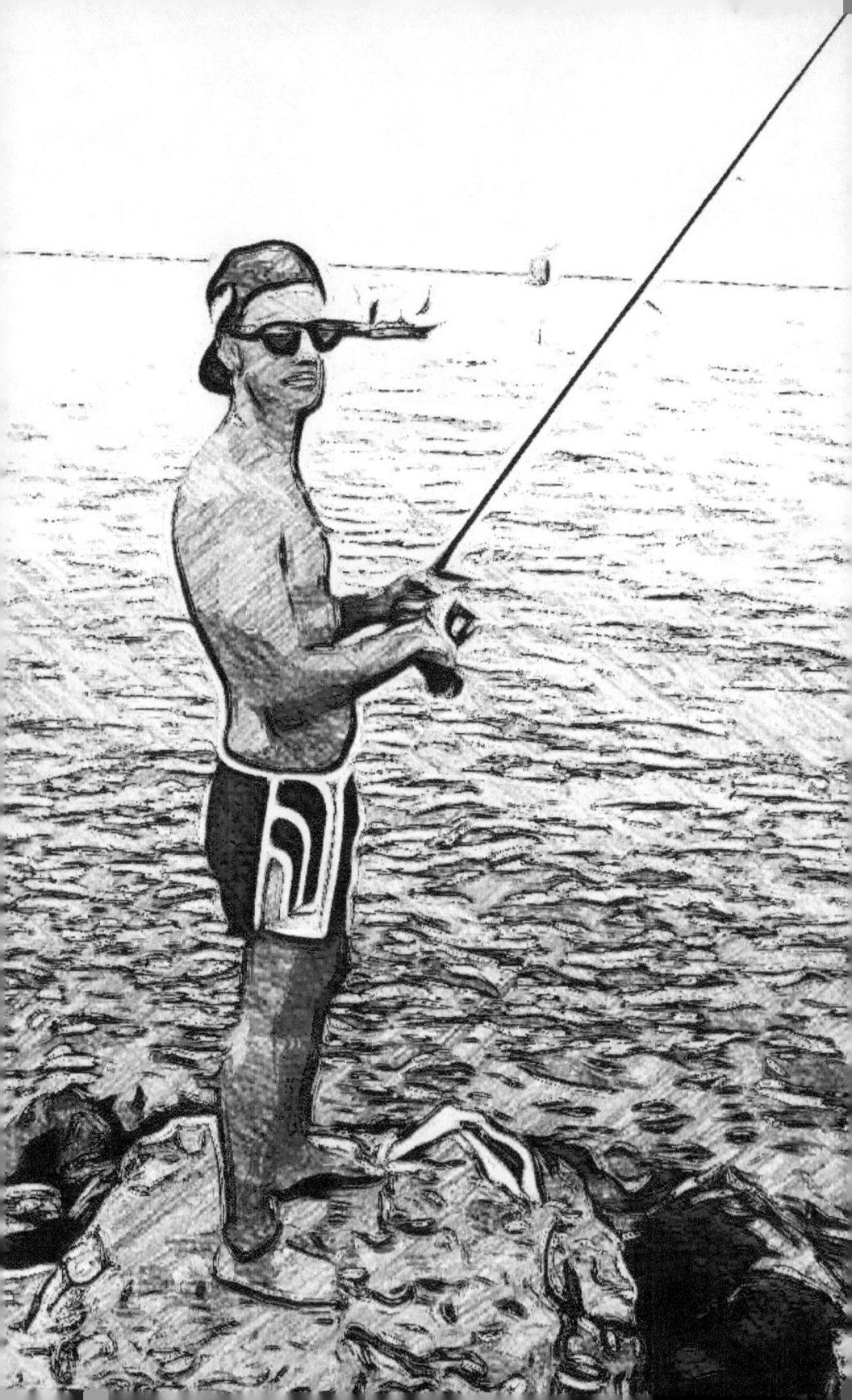

www.ingramcontent.com/pod-product-compliance
Lightning Source LLC
Chambersburg PA
CBHW021505210526
45463CB00002B/894